Whitman's Men

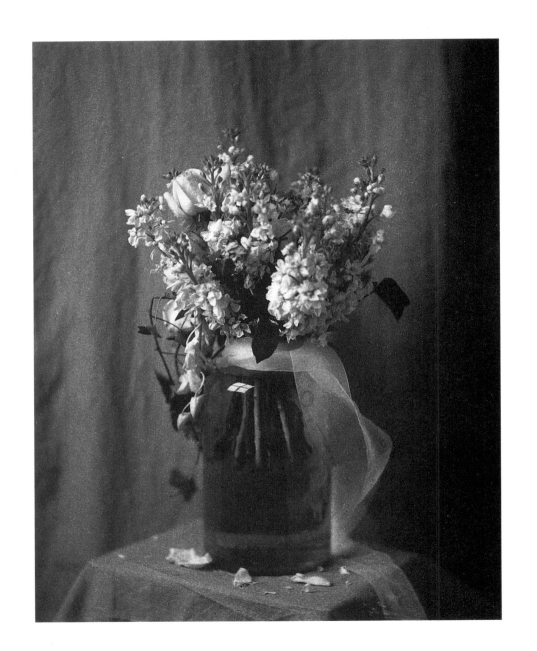

Whitman's Men

Walt Whitman's Calamus Poems
Celebrated by Contemporary Photographers

Poetry selected and introduced
by David Groff

Photography selected, edited, and
introduced by Richard Berman

UNIVERSE PUBLISHING

ACKNOWLEDGMENTS:

First and foremost, this book would not have been possible
without the beautiful images generously provided by the
photographers. We would also like to thank the following
people who assisted with suggestions and help: Scott
Bacon, Julie Saul, Edna Karakatsanis, John Wessel, Billy
O'Connor, Peter Halpert, and Philip Gefter; our colleagues
at Universe Publishing: Charles Miers, publisher, our out-
standing editor, Sandy Gilbert, and the book's designer,
Russell Hassell. And a very special thank you to Lucy
Kaylin for her insightful editorial comments.

Richard Berman
David Groff

Front cover: John Dugdale, *Comrades* (detail)
Back cover: Steve Morrison, *Untitled*, from the series,
Of the Terrible Doubt of Appearances (detail)

First published in the United States of America in 1996
by UNIVERSE PUBLISHING
A Division of Rizzoli International Publications, Inc.
300 Park Avenue South, New York, NY 10010

96 97 98 99/10 9 8 7 6 5 4 3 2 1

Library of Congress Catalog Card Number: 95-62020
Design and typography by Russell Hassell
Printed in Singapore

Whitman's American Men

An Introduction to the Calamus Poems

Walt Whitman loved his streets, his nation, and his men. His "Calamus" poems are his testament to the love that stirred his own heart, the muscle that built the open roads he relished, and the affection that he felt could remake the fate of the country he loved. First published just as the United States began to break apart in the months before the Civil War, Whitman's sequence of poems urged his country to use the bonds among men as its means and its metaphor to reconnect with its true nature. More than a century after it was written, "Calamus" remains a call to America's men to love each other openly and freely. Whitman propounded an idea that was, and still is, revolutionary: that love between men belongs at the heart of America's story.

The text of "Calamus" reprinted here is the first version of the poems as they appeared in the 1860 edition of the poet's ever-evolving masterwork, *Leaves of Grass*, published when Whitman was forty-one years old. These are the poems at their purest, most spontaneous, and most homoerotic. Whitman had not yet become the "good gray poet" whose persona would later obscure the contradictions of the flesh-and-blood man. With posterity and its propri-

eties looking over his shoulder, the bard would later alter the order of the poems and dilute some of their most intimate language. Although the poems' emotional footprints are difficult to track with any certainty, the series of forty-five numbered lyrics works in the same manner as a sonnet sequence. It is reminiscent, in fact, of other great progressions of emotions through poems, especially Shakespeare's sonnets, with much the same sense of the heartfelt, often painful vagaries of male intimacy.

The photographs featured in this book are engaged in a conversation with Whitman's poems—echoing, augmenting, and commenting upon the desires and ambitions of Whitman and the men he loved. The photographs do not in any way "fix" the complexity of Whitman's meanings. Instead, they bring an extra dimension of life to Whitman's lines, reminding us of what is both mutable and immutable: men age and die, and a nation's ambitions ripen and fall, only to reblossom.

Though we know Whitman as the father figure of American literature, the Whitman of 1860 thrived in the mire of urban life and the intricately nasty politics of his era. For many years a journalist in his

beloved Brooklyn and on the island he called, in faux-Indian fashion, "Mannahatta," Whitman was a fiercely competitive editor and reporter who knew his city inside out. He loafed with butcher's apprentices, carriage drivers, trolley conductors. He relished the way they moved, spoke and swore, and how easily they could embrace, kiss, or stroke each other—as working men of that time felt free to do. His journals describe how he would cruise the streets, catching the eyes of strangers, making friends with some, approaching others with "faint indirections," and longing to connect somehow with dozens more. As he shows through the sensuous and forthright lines of "Calamus," Walt Whitman knew firsthand what it meant in 1860 to love another man.

For the one I love most lay sleeping by me under the
 same cover in the cool night,
In the stillness, in the autumn moonbeams, his face
 was inclined toward me,
And his arm lay lightly around my breast—And that
 night I was happy.

Social and sexual historians have pointed out that, in Whitman's era, homosexuality existed as neither a noun nor a notion. Being attracted to one's own sex did not constitute a sexual "identity" or a "community." Until the late nineteenth century, when the words "heterosexuality" and "homosexuality" were first coined, all sexual urges were perceived only as they manifested themselves in sexual acts, in behaviors. Society might condemn sex between two men or two women, and even put people to death for it. Society might also choose to ignore it. And since same-sex desire was less visible, so was opposition to it. While many men and women were punished for acts of sodomy, mid-nineteenth-century America seemed much less stirred up about same-sex desire than about, say, intemperate drinking.

Whitman and his men did share something of a common language. The poet took as his concept of male companionship the notion of "adhesiveness," a term employed in the now archaic pseudoscience of phrenology—the study of human character based on the shape, size, and contours of the skull. Extremely popular and influential in its time, phrenology proposed character descriptions such as "amative" (displaying erotic love for the opposite sex) or "adhesive" (displaying friendship toward the same sex). Adhesiveness could thus give form and legitimacy to the passionate same-sex friendships experienced so often by men and women in Anglo-American cultures throughout the nineteenth century. Alfred Tennyson had such a friendship with Arthur Hallam, whose early death inspired some of the poet's most deeply felt verse. Abraham Lincoln appears to have had a similar sort of relationship with Joshua Speed, to whom he wrote passionate letters and with whom, as a young lawyer, he even shared a bed. Same-sex desire, it seems, had something of a cleared if

circumscribed piece of ground where it could sprout and sometimes flourish. Perhaps it even existed as an undocumented society, constantly regrouping and disbanding, thriving below the social telegraph networks that communicated—and recorded for historians—the nation's morals and modes of behavior.

No matter how much we comprehend the norms of the nineteenth century and understand the poet's ambivalence toward the passions that seized him, it is easy to view adhesiveness as a kind of social shield behind which some men could not only express physical affection but forge a forthrightly sexual bond. "Calamus" for today's readers cannot be simply a call for national, physical friendship; it is an erotic poem about breathing, desirous bodies. And even for Whitman, a calamus was, after all, a very phallic plant—the perfect image for the natural and prolific phenomenon he evoked in his poems.

Not only did Whitman move into the realm where sensuality blurs into sexuality, where affection dissolves into desire—he made this passion the central metaphor for how his athletic and angry young America might be reborn. In "Calamus," in his personal epic "Song of Myself," and throughout *Leaves of Grass*, Whitman connected adhesiveness with the great open road that the American soul must travel. "Affection shall solve every one of the problems of freedom," Whitman announces early on in "Calamus." Later, he resoundingly declares

I believe the main purport of These States is to found
a superb friendship, exalté, previously unknown,
Because I perceive it waits, and has been always waiting,
latent in all men.

As a prophet of the bonds that men can forge among themselves, Whitman is determined not to be separated out of the American destiny. He himself will be the glue of desire that binds us one to another: "I wish to infuse myself among you till I see it common for you to walk hand in hand." As the poet who informs his future readers, "I considered long and seriously of you before you were born," Whitman becomes for us the very spirit that sparks masculine desire. Under his aegis we make eye contact on the street, kiss a lover in public, have sex with each other, and work to stick together.

Men who love men have long seen themselves shunted off to the side roads of their cultural story. Whitman places those men at the center of his epic work. A man's loves, desires, travels, travails, and life with his companions—all these are ordinary yet heroic representations of his country's own urges, worries, romances, and bonds. The charge a man feels for another man is the elemental electricity that sparks and energizes America. Whitman's ambition is one from which all those who celebrate male desires can take heed and heart.

—DAVID GROFF

Dearest Comrades: Seven Contemporary Photographers
An Introduction

In "Calamus" Whitman addressed what he called "adhesiveness"—the love of men for men. The poems, with their themes of love and loss, continue to resonate for today's readers. In my search for images to accompany the text, I discovered seven photographers whose work is concerned with issues that relate to the poems. Interestingly, each photographer had commented on the lasting impression that Whitman's poetry had made on him. The literary critic Mark van Doren described "Calamus" as Whitman's first expression of "the furtive, yearning aspect of his soul . . . confessing an all but incurable sadness." For me, these lines perfectly sum up the poetry as well as the work of these photographers.

Working within the tradition of the male nude, Frank Yamrus has a unique perspective that is most apparent in his studies of the nude in a landscape. The subjects, usually crouching or lying, never stand or face the camera. The figures merge with the natural setting until there is a blurring between landscape and figure. While the photographs exhibit the athleticism and strength that we find in the poetry, they also suggest a sense of vulnerability and melancholy reflected in Whitman's work.

Robert Flynt's magical conceptions are all created with underwater photography, a practice he has employed for nearly ten years. These surreal, weightless images, which are superimposed over other photographs or diagrams, create a haunted, mysterious world. The impact of the AIDS epidemic has intensified Flynt's representations of intimacy, sexuality, and mortality, themes ever present in Whitman's poetry.

As a college student, Steve Morrison wrote a thesis that explored aspects of Whitman's *Leaves of Grass*. The photographs featured here are from a series called "Of the Terrible Doubt of Appearances," the title Whitman gave to "Calamus" poem number seven in a later version of the poem. And while the presence of Whitman clearly hovers over Morrison's work, he has also drawn from nineteenth-century medical photography and the studies of Eadweard Muybridge and Thomas Eakins. Morrison has described his work as "physical evidence"; these are portraits of gay men, some of whom have since died.

John Dugdale embraces a nineteenth-century aesthetic in both his life and work. He has been restoring his old farmhouse in the Catskill Mountains and his apartment in a Federal townhouse in New

York City's West Village to their former style. Whitman's poetry and prose have long been an important influence on Dugdale's visual vocabulary. In his work, Dugdale uses cyanotype—a simple, water-based process first developed in the 1840s. Printed on watercolor paper, these Prussian-blue images, which often include his collections of period furniture and objects, not only evoke the nineteenth century but have the physical look and feel as well. Dugdale, however, is not just copying the past. His vision is framed by a contemporary perspective. Dugdale has been HIV-positive for ten years and since 1993 has had CMV retinitis, which has left him with little vision. These works, made with the help of assistants working to Dugdale's specific instructions, are a testament to his determination as an artist who must continue to create. His view of the world and the effects this disease has had on his life are documented in these revealing autobiographical photographs.

Bill Jacobson has described his photography as an expression of "personal desire and collective loss. The work refers to those known and unknown; to the well, the dying and the dead; and to the fading of our memories and the recurring of our dreams." Jacobson's images convey the intimacy of an embrace but with a sense of sorrow. An homage to survivors, his photographs also lament life's transience. In these subtle images Jacobson's figures and landscapes seem to be on the verge of vanishing at any moment.

Russell Maynor, in his color photograph of the male nude, uses a completely modern process, the Polaroid print, which he has manipulated to create a sense of another time. His photograph captures a guilelessness and contemplativeness usually associated with nineteenth-century studio photography.

Mark Beard's hand-colored photographs confront the viewer with an immediate physicality and sensuality that is very much a part of "Calamus." His photographs suggest the working-class young men who were the focus of Whitman's affections. Given his background as a painter, Beard's grasp of light, form, and color are very much in evidence in these two beautiful, painterly photographs.

Each photographer featured here has dealt, in his own way, with themes that are integral to the "Calamus" poems. Both the poetry and the photographs reflect a sense of sadness, but also a sense of joy and a celebration of life and its uncertainties. The search for self-awareness, the hunger for love and companionship, the pain of loneliness and death: these are the timeless issues that haunted Walt Whitman and that define our lives in modern times as well.

—RICHARD BERMAN

Calamus

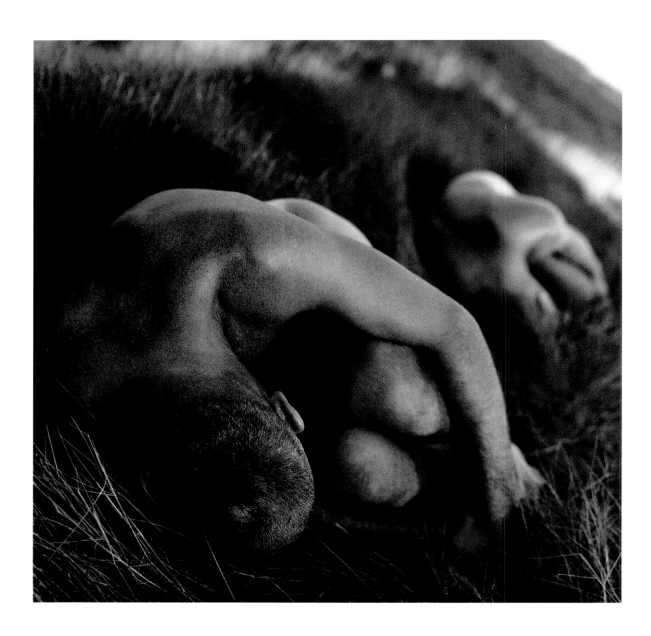

1 In paths untrodden,
In the growth by margins of pond-waters,
Escaped from the life that exhibits itself,
From all the standards hitherto published—from
 the pleasures, profits, conformities,
Which too long I was offering to feed to my Soul;
Clear to me now, standards not yet published—
 clear to me that my Soul,
That the Soul of the man I speak for, feeds, rejoices
 only in comrades;
Here, by myself, away from the clank of the world,
Tallying and talked to here by tongues aromatic,
No longer abashed—for in this secluded spot I can
 respond as I would not dare elsewhere,
Strong upon me the life that does not exhibit itself,
 yet contains all the rest,
Resolved to sing no songs to-day but those of manly
 attachment,
Projecting them along that substantial life,
Bequeathing, hence, types of athletic love,
Afternoon, this delicious Ninth Month, in my forty-
 first year,
I proceed, for all who are, or have been, young
 men,
To tell the secret of my nights and days,
To celebrate the need of comrades.

2 Scented herbage of my breast,
 Leaves from you I yield, I write, to be perused best
 afterwards,
 Tomb-leaves, body-leaves, growing up above me, above
 death,
 Perennial roots, tall leaves—O the winter shall not
 freeze you, delicate leaves,
 Every year shall you bloom again—Out from where
 you retired, you shall emerge again;
 O I do not know whether many, passing by, will discover
 you, or inhale your faint odor—but I
 believe a few will;
 O slender leaves! O blossoms of my blood! I permit
 you to tell, in your own way, of the heart that is
 under you,
 O burning and throbbing—surely all will one day be
 accomplished;
 O I do not know what you mean, there underneath
 yourselves—you are not happiness,
 You are often more bitter than I can bear—you burn
 and sting me,
 Yet you are very beautiful to me, you faint-tinged
 roots—you make me think of Death,
 Death is beautiful from you—(what indeed is beautiful,
 except Death and Love?)
 O I think it is not for life I am chanting here my
 chant of lovers—I think it must be for Death,

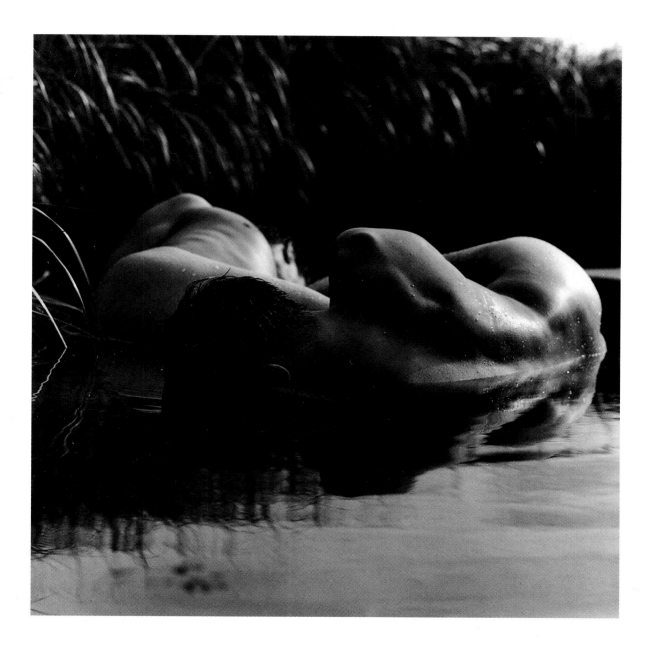

For how calm, how solemn it grows, to ascend to the
 atmosphere of lovers,
Death or life I am then indifferent—my Soul declines
 to prefer,
I am not sure but the high Soul of lovers welcomes
 death most;
Indeed, O Death, I think now these leaves mean precisely
 the same as you mean;
Grow up taller, sweet leaves, that I may see! Grow
 up out of my breast!
Spring away from the concealed heart there!
Do not fold yourselves so in your pink-tinged roots,
 timid leaves!
Do not remain down there so ashamed, herbage of my
 breast!
Come, I am determined to unbare this broad breast of
 mine—I have long enough stifled and choked;
Emblematic and capricious blades, I leave you—now
 you serve me not,
Away! I will say what I have to say, by itself,
I will escape from the sham that was proposed to me,
I will sound myself and comrades only—I will never
 again utter a call, only their call,
I will raise, with it, immortal reverberations through
 The States,

I will give an example to lovers, to take permanent
 shape and will through The States;
Through me shall the words be said to make death
 exhilarating,
Give me your tone therefore, O Death, that I may
 accord with it,
Give me yourself—for I see that you belong to me
 now above all, and are folded together above all
 —you Love and Death are,
Nor will I allow you to balk me any more with what
 I was calling life,
For now it is conveyed to me that you are the purports
 essential,
That you hide in these shifting forms of life, for
 reasons—and that they are mainly for you,
That you, beyond them, come forth, to remain, the
 real reality,
That behind the mask of materials you patiently
 wait, no matter how long,
That you will one day, perhaps, take control of all,
That you will perhaps dissipate this entire show of
 appearance,
That may be you are what it is all for—but it does
 not last so very long,
But you will last very long.

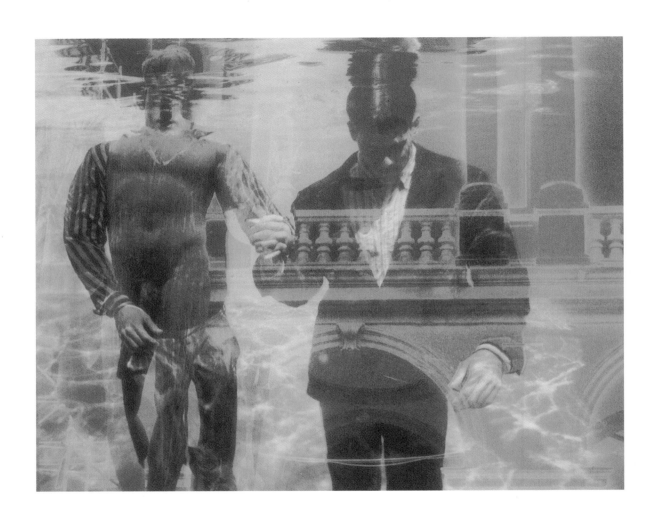

3 Whoever you are holding me now in hand,
Without one thing all will be useless,
I give you fair warning, before you attempt me
 further,
I am not what you supposed, but far different.

Who is he that would become my follower?
Who would sign himself a candidate for my affections?
 Are you he?

The way is suspicious—the result slow, uncertain,
 may-be destructive;
You would have to give up all else—I alone would
 expect to be your God, sole and exclusive,
Your novitiate would even then be long and exhausting,
The whole past theory of your life, and all conformity
 to the lives around you, would have to be abandoned;
Therefore release me now, before troubling yourself
 any further—Let go your hand from my
 shoulders,
Put me down, and depart on your way.

Or else, only by stealth, in some wood, for trial,
Or back of a rock, in the open air,
(For in any roofed room of a house I emerge not—
 nor in company,
And in libraries I lie as one dumb, a gawk, or unborn,
 or dead,)

But just possibly with you on a high hill—first
 watching lest any person, for miles around,
 approach unawares,
Or possibly with you sailing at sea, or on the beach of
 the the sea, or some quiet island,
Here to put your lips upon mine I permit you,
With the comrade's long-dwelling kiss, or the new
 husband's kiss,
For I am the new husband, and I am the comrade.

Or, if you will, thrusting me beneath your clothing,
Where I may feel the throbs of your heart, or rest
 upon your hip,
Carry me when you go forth over land or sea;
For thus, merely touching you, is enough—is best,
And thus, touching you, would I silently sleep and be
 carried eternally.

But these leaves conning, you con at peril,
For these leaves, and me, you will not understand,
They will elude you at first, and still more afterward
 —I will certainly elude you,
Even while you should think you had unquestionably
 caught me, behold!
Already you see I have escaped from you.

For it is not for what I have put into it that I have
 written this book,
Nor is it by reading it you will acquire it,

Nor do those know me best who admire me, and
 vauntingly praise me,
Nor will the candidates for my love, (unless at most a
 very few,) prove victorious,
Nor will my poems do good only—they will do just
 as much evil, perhaps more,
For all is useless without that which you may guess
 at many times and not hit—that which I
 hinted at,
Therefore release me, and depart on your way.

4 These I, singing in spring, collect for lovers,
 (For who but I should understand lovers, and all their
 sorrow and joy?
 And who but I should be the poet of comrades?)
 Collecting, I traverse the garden, the world—but
 soon I pass the gates,
 Now along the pond-side—now wading in a little,
 fearing not the wet,
 Now by the post-and-rail fences, where the old stones
 thrown there, picked from the fields, have accumulated,
 Wild-flowers and vines and weeds come up through
 the stones, and partly cover them—Beyond these
 I pass,
 Far, far in the forest, before I think where I get,
 Solitary, smelling the earthy smell, stopping now and
 then in the silence,

Alone I had thought—yet soon a silent troop gathers
 around me,
Some walk by my side, and some behind, and some
 embrace my arms or neck,
They, the spirits of friends, dead or alive—thicker
 they come, a great crowd, and I in the middle,
Collecting, dispensing, singing in spring, there I wander
 with them,
Plucking something for tokens—something for these,
 till I hit upon a name—tossing toward whoever
 is near me,
Here! lilac, with a branch of pine,
Here, out of my pocket, some moss which I pulled off
 a live-oak in Florida, as it hung trailing down,
Here, some pinks and laurel leaves, and a handful of
 sage,
And here what I now draw from the water, wading in
 the pond-side,
(O here I last saw him that tenderly loves me—and
 returns again, never to separate from me,
And this, O this shall henceforth be the token of
 comrades—this calamus-root shall,
Interchange it, youths, with each other! Let none
 render it back!)
And twigs of maple, and a bunch of wild orange, and
 chestnut,

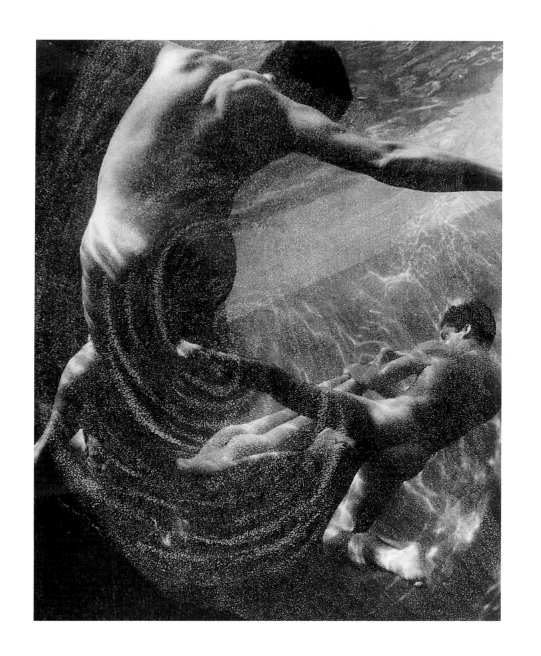

And stems of currants, and plum-blows, and the
 aromatic cedar;
These I, compassed around by a thick cloud of
 spirits,
Wandering, point to, or touch as I pass, or throw them
 loosely from me,
Indicating to each one what he shall have—giving
 something to each,
But what I drew from the water by the pond-side, that
 I reserve,
I will give of it—but only to them that love, as I
 myself am capable of loving.

5 States!
Were you looking to be held together by the lawyers?
By an agreement on a paper? Or by arms?

Away!
I arrive, bringing these, beyond all the forces of
 courts and arms,
These! to hold you together as firmly as the earth
 itself is held together.

The old breath of life, ever new,
Here! I pass it by contact to you, America.

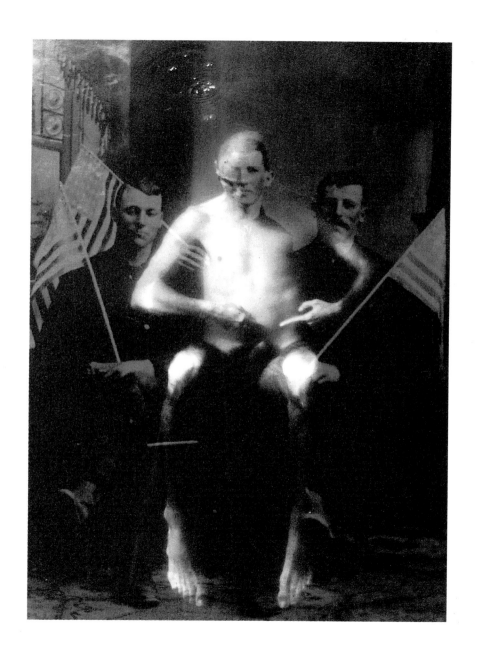

O mother! have you done much for me?
Behold, there shall from me be much done for you.

There shall from me be a new friendship—It shall
 be called after my name,
It shall circulate through The States, indifferent of
 place,
It shall twist and intertwist them through and around
 each other—Compact shall they be, showing
 new signs,
Affection shall solve every one of the problems of
 freedom,
Those who love each other shall be invincible,
They shall finally make America completely victorious,
 in my name.

One from Massachusetts shall be comrade to a Missourian,
One from Maine or Vermont, and a Carolinian and
 an Oregonese, shall be friends triune, more precious
 to each other than all the riches of the
 earth.

To Michigan shall be wafted perfume from Florida,
To the Mannahatta from Cuba or Mexico,
Not the perfume of flowers, but sweeter, and wafted
 beyond death.

No danger shall balk Columbia's lovers,
If need be, a thousand shall sternly immolate themselves
 for one,
The Kanuck shall be willing to lay down his life for
 the Kansian, and the Kansian for the Kanuck,
 on due need.

It shall be customary in all directions, in the houses
 and streets, to see manly affection,
The departing brother or friend shall salute the remaining
 brother or friend with a kiss.

There shall be innovations,
There shall be countless linked hands—namely, the
 Northeasterner's, and the Northwesterner's, and
 the Southwesterner's, and those of the interior,
 and all their brood,
These shall be masters of the world under a new
 power,
They shall laugh to scorn the attacks of all the remainder
 of the world.

The most dauntless and rude shall touch face to face
 lightly,
The dependence of Liberty shall be lovers,
The continuance of Equality shall be comrades.

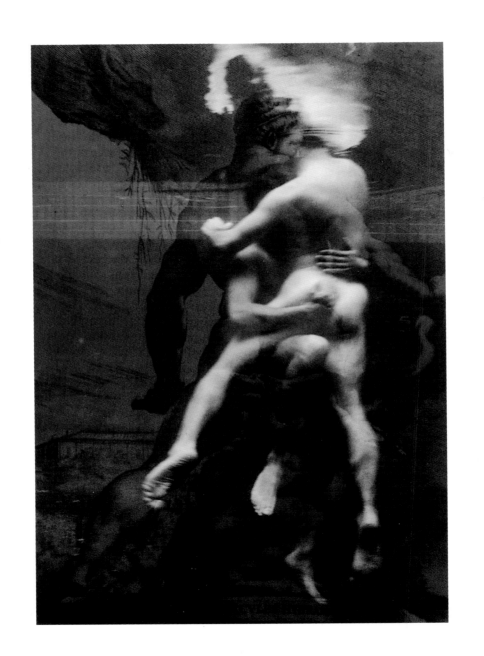

These shall tie and band stronger than hoops of iron,
I, extatic, O partners! O lands! henceforth with the
love of lovers tie you.

I will make the continent indissoluble,
I will make the most splendid race the sun ever yet
shone upon,
I will make divine magnetic lands.

I will plant companionship thick as trees along all the
rivers of America, and along the shores of the
great lakes, and all over the prairies,
I will make inseparable cities, with their arms about
each other's necks.

For you these, from me, O Democracy, to serve you,
ma femme!
For you! for you, I am trilling these songs.

6 Not heaving from my ribbed breast only,
Not in sights at night, in rage, dissatisfied with myself,
Not in those long-drawn, ill-suppressed sighs,
Not in many an oath and promise broken,
Not in my wilful and savage soul's volition,
Not in the subtle nourishment of the air,
Not in this beating and pounding at my temples and
wrists,

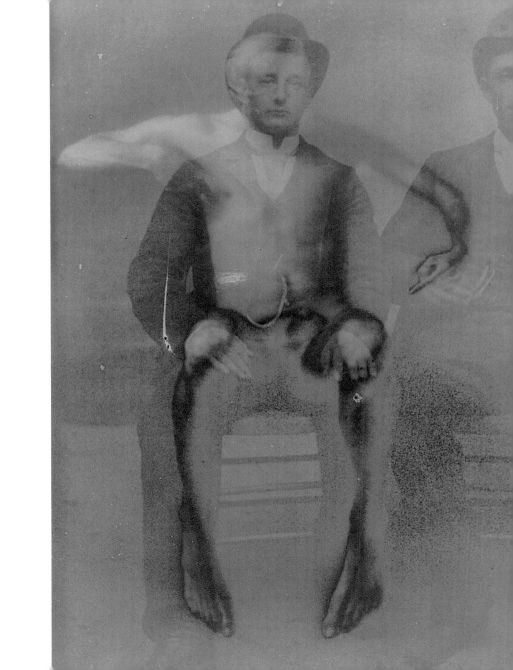

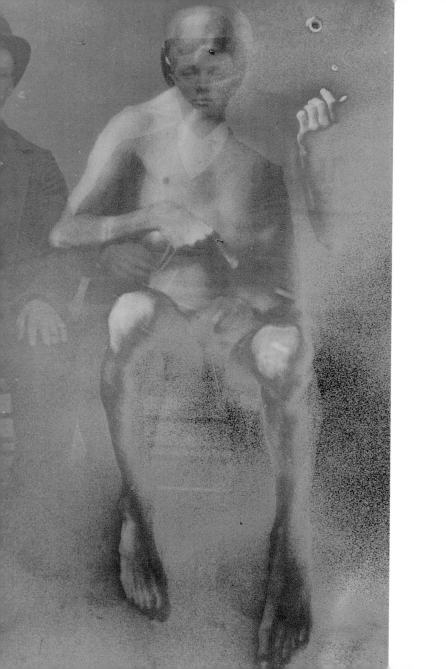

Not in the curious systole and diastole within, which
 will one day cease,
Not in many a hungry wish, told to the skies only,
Not in cries, laughter, defiances, thrown from me
 when alone, far in the wilds,
Not in husky pantings through clenched teeth,
Not in sounded and resounded words—chattering
 words, echoes, dead words,
Not in the murmurs of my dreams while I sleep,
Nor the other murmurs of these incredible dreams of
 every day,
Nor in the limbs and senses of my body, that take you
 and dismiss you continually—Not there,
Not in any or all of them, O adhesiveness! O pulse
 of my life!
Need I that you exist and show yourself, any more
 than in these songs.

7 Of the terrible question of appearances,
Of the doubts, the uncertainties after all,
That may-be reliance and hope are but speculations
 after all,
That may-be identity beyond the grave is a beautiful
 fable only,
May-be the things I perceive—the animals, plants,
 men, hills, shining and flowing waters,

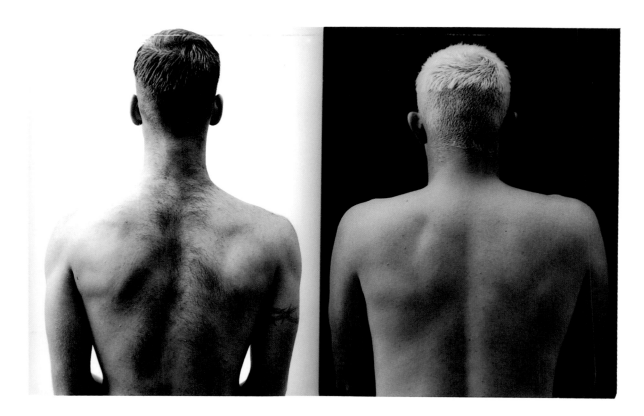

The skies of day and night—colors, densities, forms
 —May-be these are, (as doubtless they are,) only
 apparitions, and the real something has yet to be
 known,
(How often they dart out of themselves, as if to confound
 me and mock me!
How often I think neither I know, nor any man
 knows, aught of them;)
May-be they only seem to me what they are, (as
 doubtless they indeed but seem,) as from my
 present point of view—And might prove, (as of
 course they would,) naught of what they appear,
 or naught any how, from entirely changed points
 of view;
To me, these, and the like of these, are curiously
 answered by my lovers, my dear friends;
When he whom I love travels with me, or sits a long
 while holding me by the hand,
When the subtle air, the impalpable, the sense that
 words and reason hold not, surround us and
 pervade us,
Then I am charged with untold and untellable wisdom
 —I am silent—I require nothing further,
I cannot answer the question of appearances, or that
 of identity beyond the grave,
But I walk or sit indifferent—I am satisfied,
He ahold of my hand has completely satisfied me.

8 Long I thought that knowledge alone would suffice
 me—O if I could but obtain knowledge!
 Then my lands engrossed me—Lands of the prairies,
 Ohio's land, the southern savannas, engrossed
 me—For them I would live—I would be their
 orator;
 Then I met the examples of old and new heroes—I
 heard of warriors, sailors, and all dauntless persons
 —And it seemed to me that I too had it
 in me to be as dauntless as any—and would
 be so;
 And then, to enclose all, it came to me to strike up
 the songs of the New World—And then I believed
 my life must be spent in singing;
 But now take notice, land of the prairies, land of
 the south savannas, Ohio's land,
 Take notice, you Kanuck woods—and you Lake
 Huron—and all that with you roll toward
 Niagara—and you Niagara also,
 And you, Californian mountains—That you each
 and all find somebody else to be your singer of
 songs,
 For I can be your singer of songs no longer—One
 who loves me is jealous of me, and withdraws me
 from all but love,

With the rest I dispense—I sever from what I
 thought would suffice me, for it does not—it is
 now empty and tasteless to me,
I heed knowledge, and the grandeur of The States,
 and the example of heroes, no more,
I am indifferent to my own songs—I will go with
 him I love,
It is to be enough for us that we are together—We
 never separate again.

9 Hours continuing long, sore and heavy-hearted,
Hours of the dusk, when I withdraw to a lonesome
 and unfrequented spot, seating myself, leaning
 my face in my hands;
Hours sleepless, deep in the night, when I go forth,
 speeding swiftly the country roads, or through
 the city streets, or pacing miles and miles, stifling
 plaintive cries;
Hours discouraged, distracted—for the one I cannot
 content myself without, soon I saw him content
 himself without me;
Hours when I am forgotten, (O weeks and months are
 passing, but I believe I am never to forget!)
Sullen and suffering hours! (I am ashamed—but it
 is useless—I am what I am;)
Hours of my torment—I wonder if other men ever
 have the like, out of the like feelings?

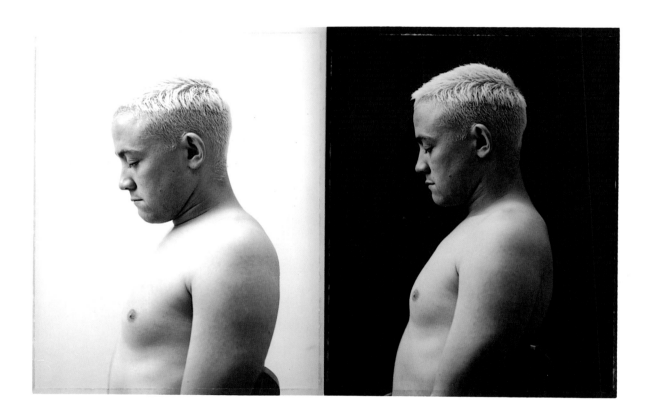

Is there even one other like me—distracted—his
 friend, his lover, lost to him?
Is he too as I am now? Does he still rise in the morning,
 dejected, thinking who is lost to him? and
 at night, awaking, think who is lost?
Does he too harbor his friendship silent and endless?
 harbor his anguish and passion?
Does some stray reminder, or the casual mention of a
 name, bring the fit back upon him, taciturn and
 deprest?
Does he see himself reflected in me? In these hours,
 does he see the face of his hours reflected?

10 You bards of ages hence! when you refer to me, mind
 not so much my poems,
Nor speak of me that I prophesied of The States, and
 led them the way of their glories;
But come, I will take you down underneath this
 impassive exterior—I will tell you what to say
 of me:
Publish my name and hang up my picture as that of
 the tenderest lover,
The friend, the lover's portrait, of whom his friend, his
 lover, was fondest,

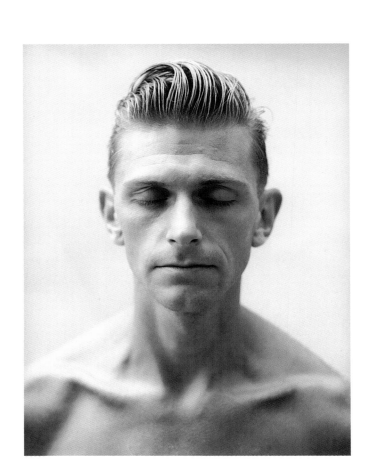

Who was not proud of his songs, but of the measureless
 ocean of love within him—and freely poured
 it forth,
Who often walked lonesome walks, thinking of his
 dear friends, his lovers,
Who pensive, away from one he loved, often lay sleepless
 and dissatisfied at night,
Who knew too well the sick, sick dread lest the one
 he loved might secretly be indifferent to him,
Whose happiest days were far away, through fields, in
 woods, on hills, he and another, wandering hand
 in hand, they twain, apart from other men,
Who oft as he sauntered the streets, curved with his
 arm the shoulder of his friend—while the arm of
 his friend rested upon him also.

11 When I heard at the close of the day how my name
 had been received with plaudits in the capitol,
 still it was not a happy night for me that followed;
And else, when I caroused, or when my plans were
 accomplished, still I was not happy;
But the day when I rose at dawn from the bed of
 perfect health, refreshed, singing, inhaling the
 ripe breath of autumn,

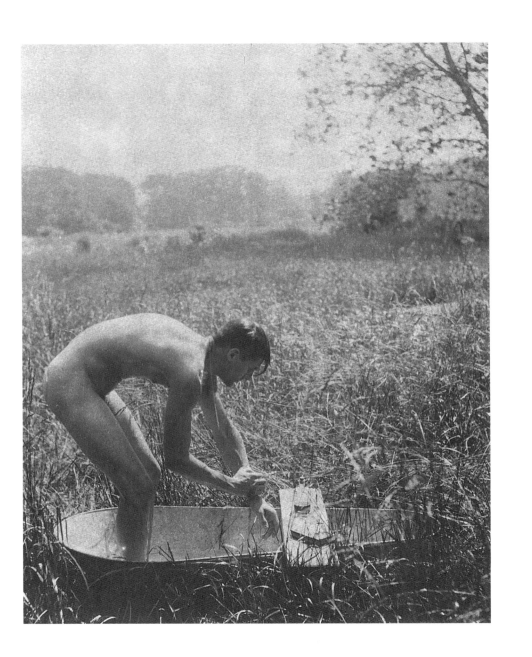

When I saw the full moon in the west grow pale and
 disappear in the morning light,
When I wandered alone over the beach, and, undressing,
 bathed, laughing with the cool waters, and
 saw the sun rise,
And when I thought how my dear friend, my lover,
 was on his way coming, O then I was happy;
O then each breath tasted sweeter—and all that day
 my food nourished me more—And the beautiful
 day passed well,
And the next came with equal joy—And with the
 next, at evening, came my friend;
And that night, while all was still, I heard the waters
 roll slowly continually up the shores,
I heard the hissing rustle of the liquid and sands,
 as directed to me, whispering, to congratulate
 me,
For the one I love most lay sleeping by me under the
 same cover in the cool night,
In the stillness, in the autumn moonbeams, his face
 was inclined toward me,
And his arm lay lightly around my breast—And that
 night I was happy.

12 Are you the new person drawn toward me, and asking
 something significant from me?
 To begin with, take warning—I am probably far
 different from what you suppose;
 Do you suppose you will find in me your ideal?
 Do you think it so easy to have me become your
 lover?
 Do you think the friendship of me would be unalloyed
 satisfaction?
 Do you suppose I am trusty and faithful?
 Do you see no further than this façade—this smooth
 and tolerant manner of me?
 Do you suppose yourself advancing on real ground
 toward a real heroic man?
 Have you no thought, O dreamer, that it may be all
 maya, illusion? O the next step may precipitate
 you!
 O let some past deceived one hiss in your ears, how
 many have prest on the same as you are pressing
 now,
 How many have fondly supposed what your are supposing
 now—only to be disappointed.

13 Calamus taste,
 (For I must change the strain—these are not to be
 pensive leaves, but leaves of joy,)
 Roots and leaves unlike any but themselves,

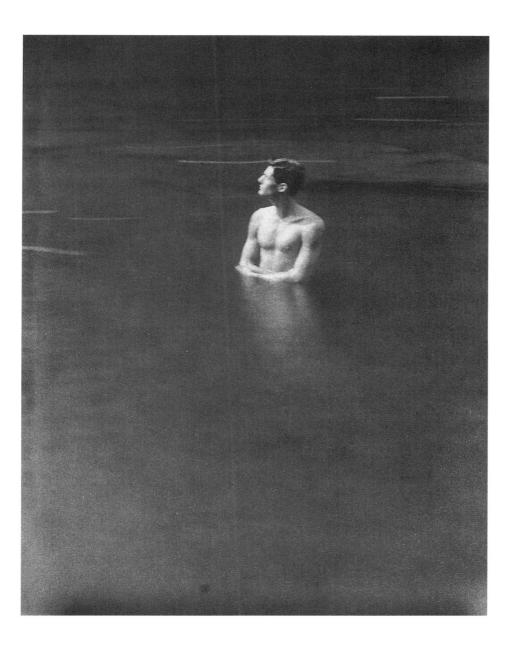

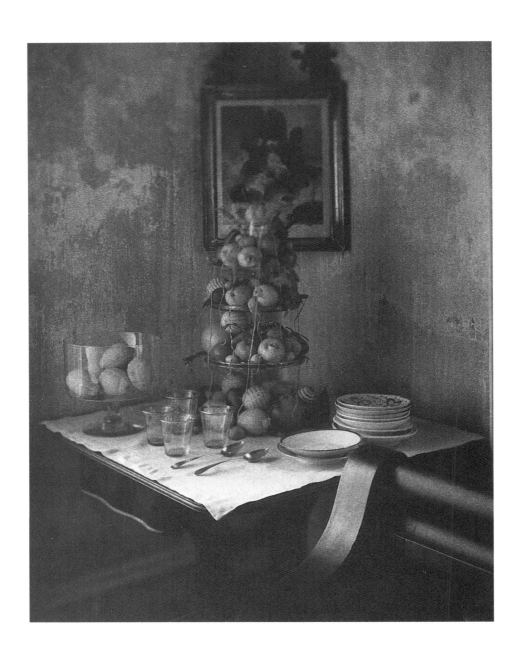

Scents brought to men and women from the wild
 woods, and from the pond-side,
Breast-sorrel and pinks of love—fingers that wind
 around tighter than vines,
Gushes from the throats of birds, hid in the foliage
 of trees, as the sun is risen,
Breezes of land and love—Breezes set from living
 shores out to you on the living sea—to you,
 O sailors!
Frost-mellowed berries, and Third Month twigs, offered
 fresh to young persons wandering out in
 the fields when the winter breaks up,
Love-buds, put before you and within you, whoever
 you are,
Buds to be unfolded on the old terms,
If you bring the warmth of the sun to them, they will
 open, and bring form, color, perfume, to you,
If you become the aliment and the wet, they will
 become flowers, fruits, tall branches and trees,
They are comprised in you just as much as in themselves
 —perhaps more than in themselves,
They are not comprised in one season or succession,
 but many successions,
They have come slowly up out of the earth and me,
 and are to come slowly up out of you.

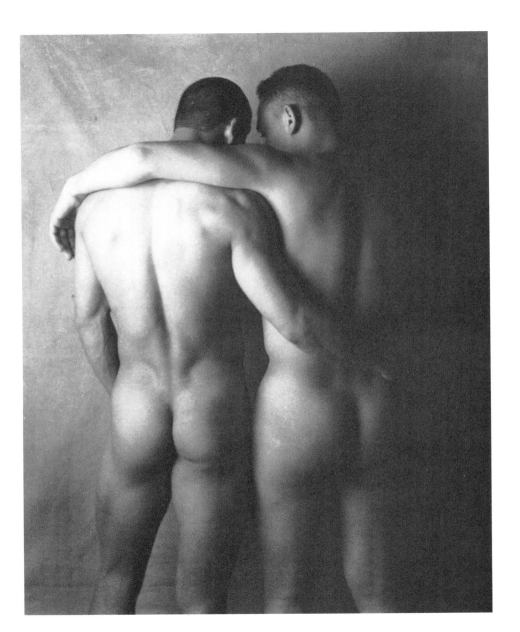

14 Not heat flames up and consumes,
 Not sea-waves hurry in and out,
 Not the air, delicious and dry, the air of the ripe
 summer, bears lightly along white down-balls of
 myriads of seeds, wafted, sailing gracefully, to
 drop where they may,
 Not these—O none of these, more than the flames
 of me, consuming, burning for his love whom I
 love!
 O none, more than I, hurrying in and out;
 Does the tide hurry, seeking something, and never
 give up? O I the same;
 O nor down-balls, nor perfumes, nor the high
 rain-emitting clouds, are borne through the open
 air,
 Any more than my Soul is borne through the open
 air,
 Wafted in all directions, O love, for friendship, for
 you.

15 O drops of me! trickle, slow drops,
 Candid, from me falling—drip, bleeding drops,
 From wounds made to free you whence you were
 prisoned,

From my face—from my forehead and lips,
From my breast—from within where I was concealed
 —Press forth, red drops—confession
 drops,
Stain every page—stain every song I sing, every
 word I say, bloody drops,
Let them know your scarlet heat—let them glisten,
Saturate them with yourself, all ashamed and wet,
Glow upon all I have written or shall write, bleeding
 drops,
Let it all be seen in your light, blushing drops.

16 Who is now reading this?

May-be one is now reading this who knows some
 wrong-doing of my past life,
Or may-be a stranger is reading this who has secretly
 loved me,
Or may-be one who meets all my grand assumptions
 and egotisms with derision,
Or may-be one who is puzzled at me.

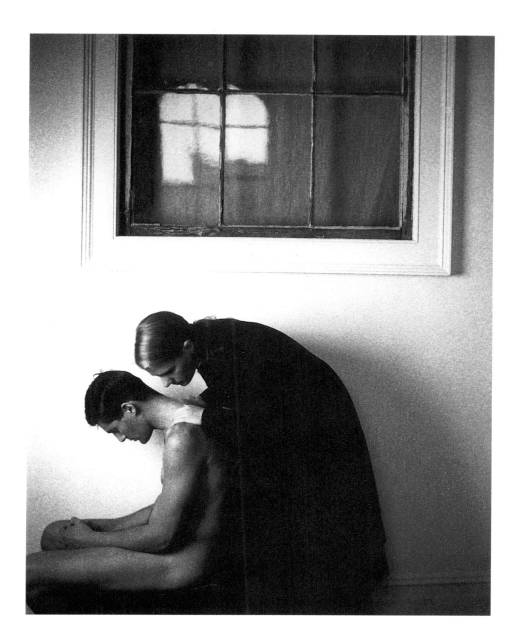

As if I were not puzzled at myself!
Or as if I never deride myself! (O conscience-struck!
 O self-convicted!)
Or as if I do not secretly love strangers! (O tenderly,
 a long time, and never avow it;)
Or as if I did not see, perfectly well, interior in
 myself, the stuff of wrong-doing,
Or as if it could cease transpiring from me until it
 must cease.

17 Of him I love day and night, I dreamed I heard he
 was dead,
And I dreamed I went where they had buried him I
 love—but he was not in that place,
And I dreamed I wandered, searching among burial-
 places, to find him,
And I found that every place was a burial-place,
The houses full of life were equally full of death,
 (This house is now,)
The streets, the shipping, the places of amusement,
 the Chicago, Boston, Philadelphia, the Mannahatta,
 were as full of the dead as of the living,
And fuller, O vastly fuller, of the dead than of the
 living;
—And what I dreamed I will henceforth tell to every
 person and age,

And I stand henceforth bound to what I dreamed;
And now I am willing to disregard burial-places, and
 dispense with them,
And if the memorials of the dead were put up indifferently
 everywhere, even in the room where I
 eat or sleep, I should be satisfied,
And if the corpse of any one I love, or if my own
 corpse, be duly rendered to powder, and poured
 in the sea, I shall be satisfied,
Or if it be distributed to the winds, I shall be satisfied.

18 City of my walks and joys!
City whom that I have lived and sung there will one
 day make you illustrious,
Not the pageants of you—not your shifting tableaux,
 your spectacles, repay me,
Not the interminable rows of your houses—nor the
 ships at the wharves,
Nor the processions in the streets, nor the bright windows,
 with goods in them,
Nor to converse with learned persons, or bear my
 share in the soiree or feast;
Nor those—but, as I pass, O Manhattan! your frequent
 and swift flash of eyes offering me love,
Offering me the response of my own—these repay
 me,
Lovers, continual lovers, only repay me.

19 Mind you the the timid models of the rest, the
 majority?
 Long I minded them, but hence I will not—for I
 have adopted models for myself, and now offer
 them to The Lands.

 Behold this swarthy and unrefined face—these gray
 eyes,
 This beard—the white wool, unclipt upon my neck,
 My brown hands, and the silent manner of me, without
 charm;
 Yet comes one, a Manhattanese, and ever at parting,
 kisses me lightly on the lips with robust love,
 And I, in the public room, or on the crossing of the
 street, or on the ship's deck, kiss him in return;
 We observe that salute of American comrades, land
 and sea,
 We are those two natural and nonchalant persons.

20 I saw in Louisiana a live-oak growing,
 All alone stood it, and the moss hung down from the
 branches,
 Without any companion it grew there, uttering joyous
 leaves of dark green,
 And its look, rude, unbending, lusty, made me think
 of myself,

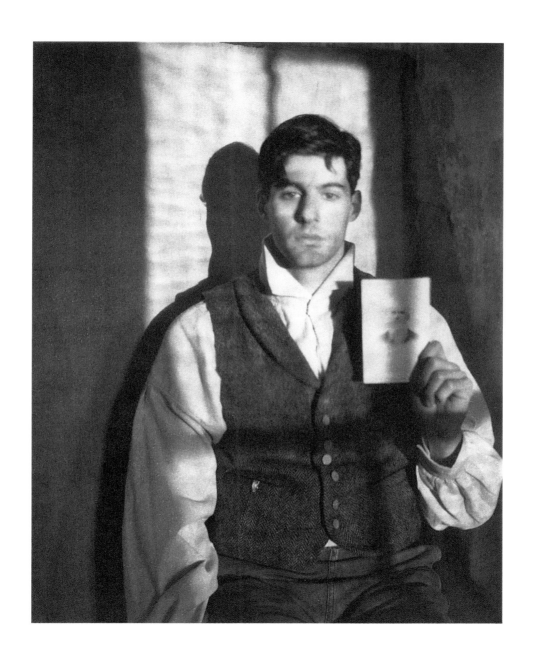

But I wondered how it could utter joyous leaves,
 standing alone there, without its friend, its
 lover near—for I knew I could not,
And I broke off a twig with a certain number of
 leaves upon it, and twined around it a little
 moss,
And brought it away—and I have placed it in sight
 in my room,
It is not needed to remind me as of my own dear
 friends,
(For I believe lately I think of little else than of
 them,)
Yet it remains to me a curious token—it makes me
 think of manly love;
For all that, and though the live-oak glistens there in
 Louisiana, solitary, in a wide flat space,
Uttering joyous leaves all its life, without a friend, a
 lover, near,
I know very well I could not.

21 Music always round me, unceasing, unbeginning—
 yet long untaught I did not hear,
But now the chorus I hear, and am elated,
A tenor, strong, ascending, with power and health,
 with glad notes of day-break I hear,
A soprano, at intervals, sailing buoyantly over the
 tops of immense waves,

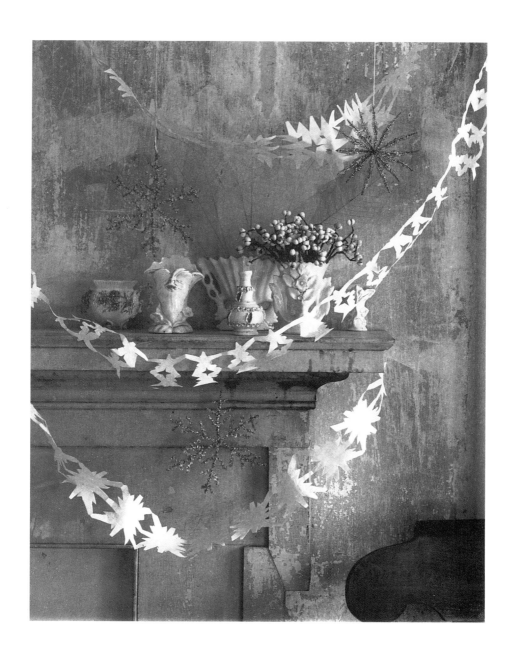

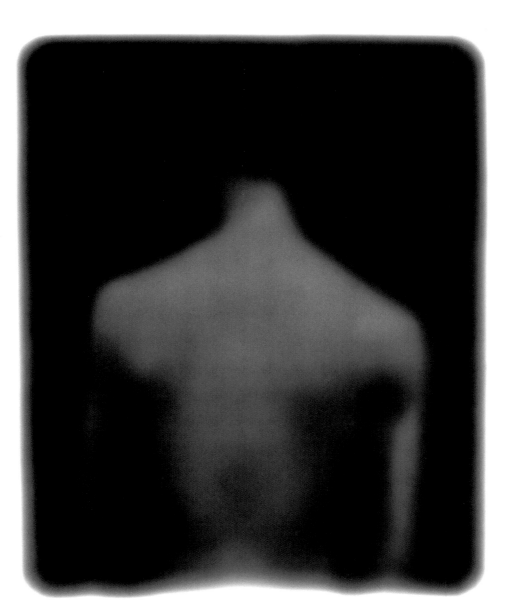

A transparent base, shuddering lusciously under and
 through the universe,
The triumphant tutti—the funeral wailings, with
 sweet flutes and violins—All these I fill myself
 with;
I hear not the volumes of sound merely—I am
 moved by the exquisite meanings,
I listen to the different voices winding in and out,
 striving, contending with fiery vehemence to
 excel each other in emotion,
I do not think the performers know themselves—But
 now I think I begin to know them.

22 Passing stranger! you do not know how longingly
 I look upon you,
You must be he I was seeking, or she I was seeking,
 (It comes to me, as of a dream,)
I have somewhere surely lived a life of joy with
 you,
All is recalled as we flit by each other, fluid, affectionate,
 chaste, matured,
You grew up with me, were a boy with me, or a girl
 with me,
I ate with you, and slept with you—your body has
 become not yours only, nor left my body mine
 only,

You give me the pleasure of your eyes, face, flesh, as
 we pass—you take of my beard, breast, hands,
 in return,
I am not to speak to you—I am to think of you
 when I sit alone, or wake at night alone,
I am to wait—I do not doubt I am to meet you
 again,
I am to see to it that I do not lose you.

23 This moment as I sit alone, yearning and thoughtful,
 it seems to me there are other men in other
 lands, yearning and thoughtful;
It seems to me I can look over and behold them,
 in Germany, Italy, France, Spain—Or far, far
 away, in China, or in Russia or India—talking
 other dialects;
And it seems to me if I could know those men better,
 I should become attached to them, as I do to men
 in my own lands,
It seems to me they are as wise, beautiful, benevolent,
 as any in my own lands;
O I know we should be brethren and lovers,
I know I should be happy with them.

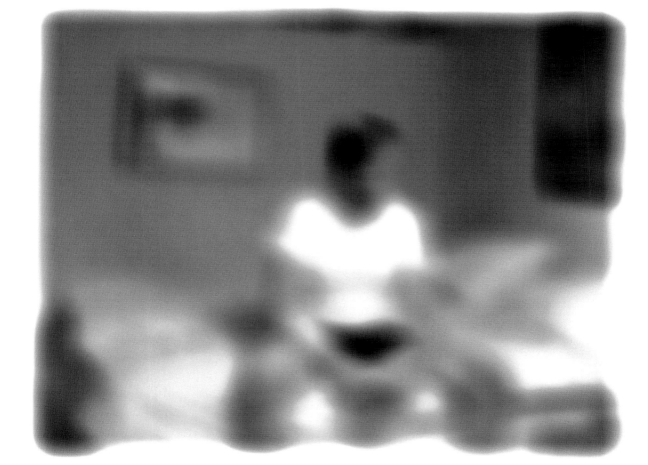

24 I hear it is charged against me that I seek to destroy
 institutions;
 But really I am neither for nor against institutions,
 (What indeed have I in common with them?—Or
 what with the destruction of them?)
 Only I will establish in the Mannahatta, and in every
 city of These States, inland and seaboard,
 And in the fields and woods, and above every keel
 little or large, that dents the water,
 Without edifices, or rules, or trustees, or any argument,
 The institution of the dear love of comrades.

25 The prairie-grass dividing—its own odor breathing,
 I demand of it the spiritual corresponding,
 Demand the most copious and close companionship
 of men,
 Demand the blades to rise of words, acts, beings,
 Those of the open atmosphere, coarse, sunlit, fresh,
 nutritious,
 Those that go their own gait, erect, stepping with
 freedom and command—leading, not following,
 Those with a never-quell'd audacity—those with
 sweet and lusty flesh, clear of taint, choice and
 chary of its love-power,

Those that look carelessly in the faces of Presidents
and Governors, as to say, *Who are you?*
Those of earth-born passion, simple, never constrained,
never obedient,
Those of inland America.

26 We two boys together clinging,
One the other never leaving,
Up and down the roads going—North and South
excursions making,
Power enjoying—elbows stretching—fingers clutching,
Armed and fearless—eating, drinking, sleeping, loving,
No law less than ourselves owning—sailing, soldiering,
thieving, threatening,
Misers, menials, priests alarming—air breathing,
water drinking, on the turf or the sea-beach
dancing,
With birds singing—With fishes swimming—With
trees branching and leafing,
Cities wrenching, ease scorning, statutes mocking,
feebleness chasing,
Fulfilling our foray.

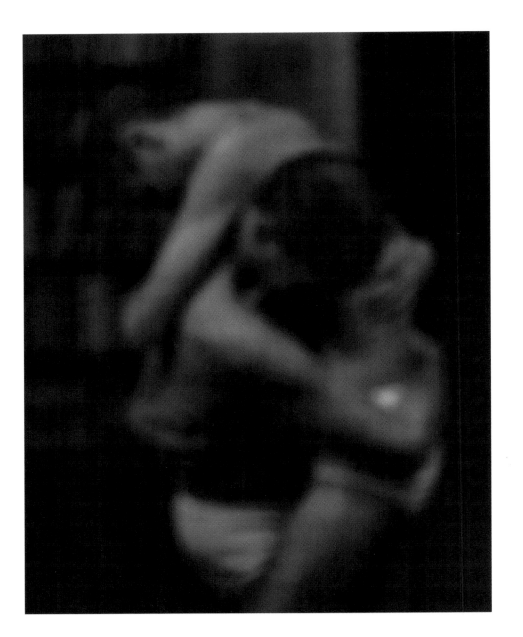

27 O love!

O dying—always dying!

O the burials of me, past and present!

O me, while I stride ahead, material, visible, imperious
 as ever!

O me, what I was for years, now dead, (I lament not
 —I am content;)

O to disengage myself from those corpses of me,
 which I turn and look at, where I cast them!

To pass on, (O living! always living!) and leave the
 corpses behind!

28 When I peruse the conquered fame of heroes, and the
 victories of mighty generals, I do not envy the
 generals,

Nor the President in his Presidency, nor the rich in
 his great house;

But when I read of the brotherhood of lovers, how it
 was with them,

How through life, through dangers, odium, unchanging,
 long and long,

Through youth, and through middle and old age, how
 unfaltering, how affectionate and faithful they
 were,

Then I am pensive—I hastily put down the book,
 and walk away, filled with the bitterest envy.

29 One flitting glimpse, caught through an interstice,
Of a crowd of workmen and drivers in a bar-room,
 around the stove, late of a winter night—And
 I unremarked, seated in a corner;
Of a youth who loves me, and whom I love, silently
 approaching, and seating himself near, that he
 may hold me by the hand;
A long while, amid the noises of coming and going
 —of drinking and oath and smutty jest,
There we two, content, happy in being together,
 speaking little, perhaps not a word.

30 A promise and gift to California,
Also to the great Pastoral Plains, and for Oregon:
Sojourning east a while longer, soon I travel to you,
 to remain, to teach robust American love;
For I know very well that I and robust love belong
 among you, inland, and along the Western
 Sea,
For These States tend inland, and toward the Western
 Sea—and I will also.

31 What ship, puzzled at sea, cons for the true reckoning?
Or, coming in, to avoid the bars, and follow the channel,
 a perfect pilot needs?
Here, sailor! Here, ship! take aboard the most perfect
 pilot,

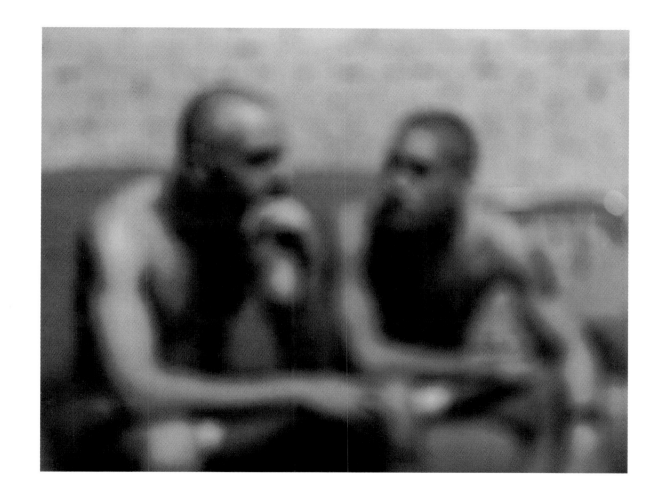

Whom, in a little boat, putting off, and rowing, I,
 hailing you, offer.

What place is besieged, and vainly tries to raise the
 siege?
Lo! I send to that place a commander, swift, brave,
 immortal,
And with him horse and foot—and parks of artillery,
And artillerymen, the deadliest that ever fired gun.

32 What think you I take my pen in hand to record?
The battle-ship, perfect-model'd, majestic, that I saw
 pass the offing to-day under full sail?
The splendors of the past day? Or the splendor of the
 night that envelops me?
Or the vaunted glory and growth of the great city
 spread around me?—No;
But I record of two simple men I saw to-day, on the
 pier, in the midst of the crowd, parting the parting
 of dear friends,
The one to remain hung on the other's neck, and passionately
 kissed him,
While the one to depart, tightly prest the one to
 remain in his arms.

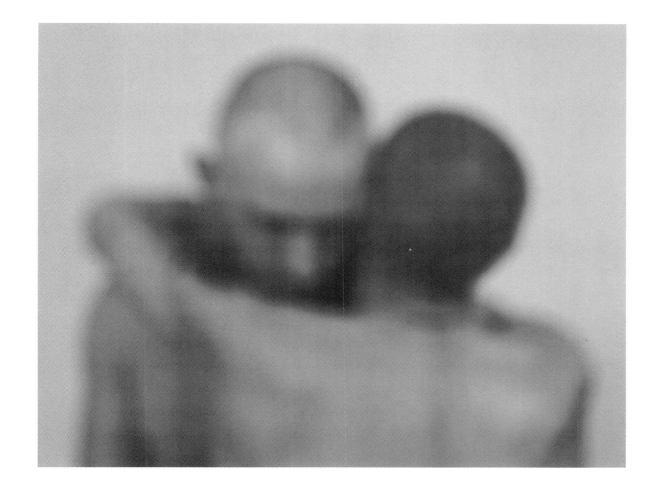

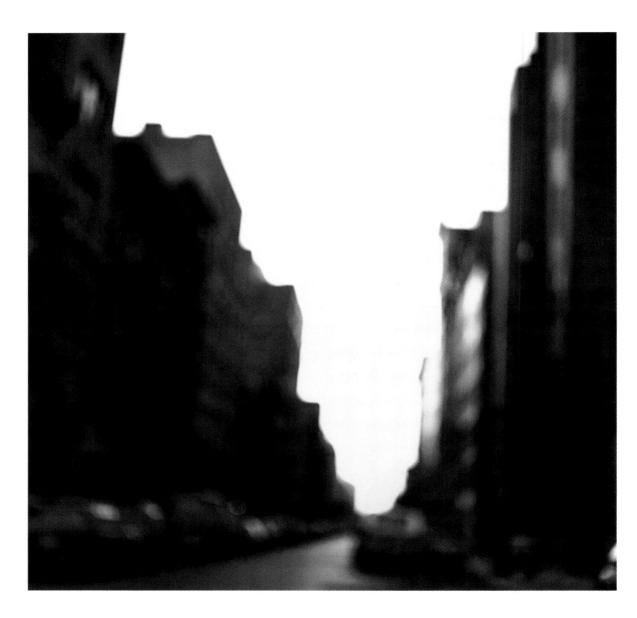

33 No labor-saving machine,
Nor discovery have I made,
Nor will I be able to leave behind me any wealthy
 bequest to found a hospital or library,
Nor reminiscence of any deed of courage, for America,
Nor literary success, nor intellect—nor book for the
 book-shelf;
Only these carols, vibrating through the air, I leave,
For comrades and lovers.

34 I dreamed in a dream, I saw a city invincible to the
 attacks of the whole of the rest of the earth,
I dreamed that was the new City of Friends,
Nothing was greater there than the quality of robust
 love—it led the rest,
It was seen every hour in the actions of the men of
 that city,
And in all their looks and words.

35 To you of New England,
To the man of the Seaside State, and of Pennsylvania,
To the Kanadian of the north—to the Southerner I
 love,
These, with perfect trust, to depict you as myself—
 the germs are in all men;

I believe the main purport of These States is to found
a superb friendship, exalté, previously unknown,
Because I perceive it waits, and has been always waiting,
latent in all men.

3 6 Earth! my likeness!
Though you look so impassive, ample and spheric
there,
I now suspect that is not all;
I now suspect there is something fierce in you, eligible
to burst forth;
For an athlete is enamoured of me—and I of him,
But toward him there is something fierce and terrible
in me, eligible to burst forth,
I dare not tell it in words—not even in these songs.

3 7 A leaf for hand in hand!
You natural persons old and young! You on the
Eastern Sea, and you on the Western!
You on the Mississippi, and all the branches and
bayous of the Mississippi!
You friendly boatmen and mechanics! You roughs!
You twain! And all processions moving along the
streets!
I wish to infuse myself among you till I see it common
for you to walk hand in hand.

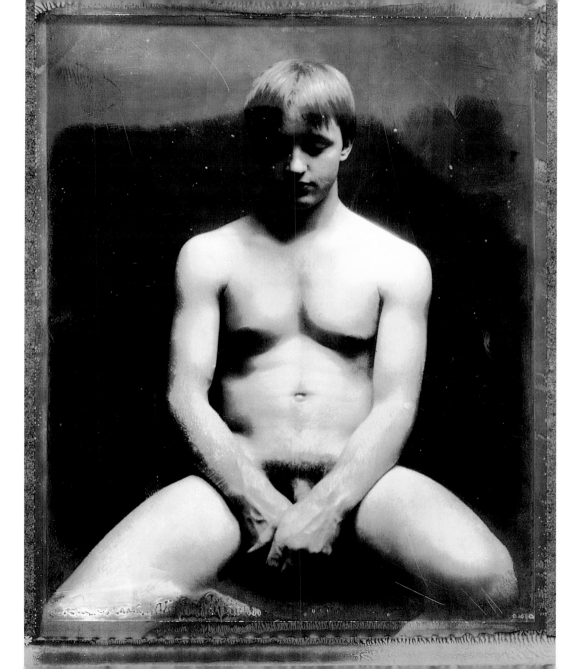

38 Primeval my love for the woman I love,
 O bride! O wife! more resistless, more enduring
 than I can tell, the thought of you!
 Then separate, as disembodied, the purest born,
 The ethereal, the last athletic reality, my consolation,
 I ascend—I float in the regions of your love, O man,
 O sharer of my roving life.

39 Sometimes with one I love, I fill myself with rage, for
 fear I effuse unreturned love;
 But now I think there is no unreturned love—the
 pay is certain, one way or another,
 Doubtless I could not have perceived the universe,
 or written one of my poems, if I had not freely
 given myself to comrades, to love.

40 That shadow, my likeness, that goes to and fro, seeking
 a livelihood, chattering, chaffering,
 How often I find myself standing and looking at it
 where it flits,
 How often I question and doubt whether that is really
 me;
 But in these, and among my lovers, and carolling my
 songs,
 O I never doubt whether that is really me.

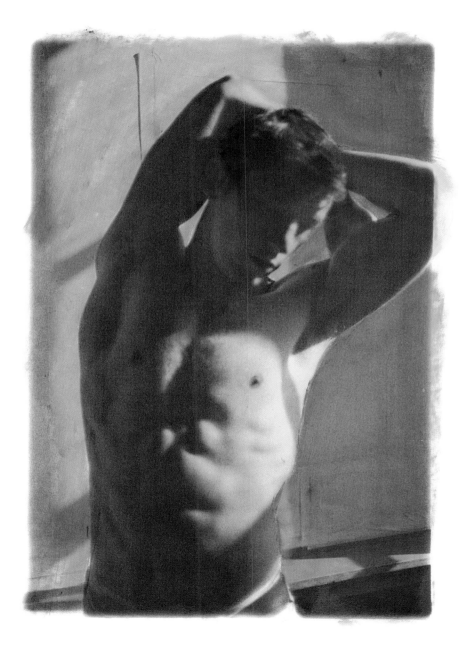

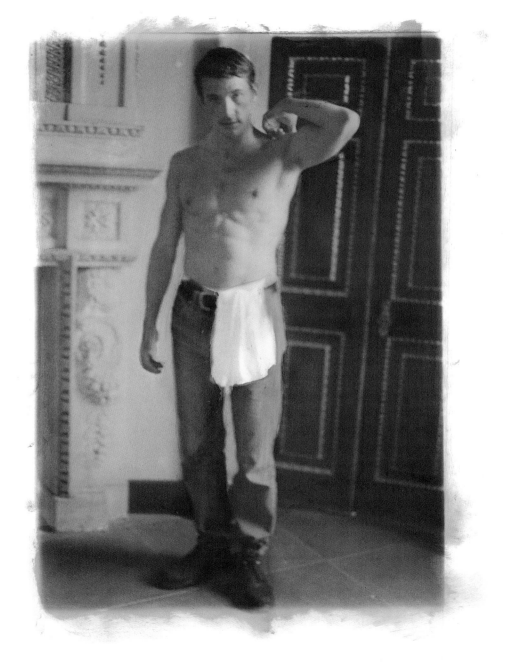

4 1 Among the men and women, the multitude, I perceive
 one picking me out by secret and divine
 signs,
 Acknowledging none else—not parent, wife, husband,
 brother, child, any nearer than I am;
 Some are baffled—But that one is not—that one
 knows me.

 Lover and perfect equal!
 I meant that you should discover me so, by my faint
 indirections,
 And I, when I meet you, mean to discover you by the
 like in you.

4 2 To the young man, many things to absorb, to engraft,
 to develop, I teach, to help him become élève of
 mine,
 But if blood like mine circle not in his veins,
 If he be not silently selected by lovers, and do not
 silently select lovers,
 Of what use is it that he seek to become élève of
 mine?

4 3 O you whom I often and silently come where you
 are, that I may be with you,
 As I walk by your side, or sit near, or remain in the
 same room with you,

Little you know the subtle electric fire that for your
 sake is playing within me.

4 4 Here my last words, and the most baffling,
 Here the frailest leaves of me, and yet my strongest-
 lasting,
 Here I shade down and hide my thoughts—I do not
 expose them,
 And yet they expose me more than all my other
 poems.

4 5 Full of life, sweet-blooded, compact, visible,
 I, forty years old the Eighty-third Year of The States,
 To one a century hence, or any number of centuries
 hence,
 To you, yet unborn, these, seeking you.

 When you read these, I, that was visible, am become
 invisible;
 Now it is you, compact, visible, realizing my poems,
 seeking me,
 Fancying how happy you were, if I could be with
 you, and become your lover;
 Be it as if I were with you. Be not too certain but I
 am now with you.

MARK BEARD moved from Utah to New York in 1980. A painter, printmaker, and set designer, he has exhibited widely throughout America and Europe. Recently he was commissioned to design a small opera house and its accompanying murals for the State Theatre of Cologne. He is currently designing the Children's Opera House for the State Opera House of Cologne as well. He has produced ten artists' books. His work is represented in many public collections, including those of the Metropolitan Museum of Art, the Whitney Museum of American Art, the Museum of Modern Art, the Albertina in Vienna, and the Graphische Sammlung in Munich.

JOHN DUGDALE lives and works in New York City and Stone Ridge, New York. In addition to numerous solo exhibitions in New York, Dugdale's work has been included in exhibitions around America. His photographs will appear in upcoming exhibitions in San Francisco and at Prospect 96 in the Frankfurter Kunstverein, Frankfurt, Germany. A monograph of his recent work, *Lengthening Shadows before Nightfall*, was published in November 1995. John Dugdale is represented by the Wessel O'Connor Gallery, New York.

ROBERT FLYNT has exhibited widely in both America and Europe. He has been the recipient of various awards, including the Massachusetts Council on the Arts and Humanities' New Works Grant. His work appears in the public collections of the Metropolitan Museum of Art, the Museum of Modern Art, the Los Angeles County Museum of Art, and the Baltimore Museum of Art, among others. Flynt will have a monograph of his work published in the fall of 1996. He resides in New York City and is represented by the Witkin Gallery, New York.

BILL JACOBSON, who has exhibited extensively in both America and Europe, has been the recipient of fellowships and residencies from the Aaron Siskind Foundation, the New York Foundation of the Arts, and the Edward Albee Foundation. His work appears in several public collections, including those of the Metropolitan Museum of Art and the San Francisco Museum of Modern Art. Jacobson lives in New York City and is represented by the Julie Saul Gallery, New York.

RUSSELL MAYNOR is a painter and photographer who has lived in New York City since 1989. He has exhibited his work in New York, London, and Toronto. His recent work has been published in *Lust, the Body Politic: Contemporary Photographers of the Male Nude* and in several New York journals, as well as *The New York Times*.

STEVE MORRISON originally from Toronto, recently moved to New York City from San Francisco. He has exhibited throughout Canada and America and in Brussels, Belgium. Morrison has been the recipient of awards from a number of organizations, including the Canada Council and the Ontario Arts Council. His photographs are included in the public collections of many museums, among them the Princeton University Art Museum and Polaroid's Domestic and International Collections. Morrison is represented by the Wessel O'Connor Gallery, New York.

FRANK YAMRUS, a self-taught photographer, lives and works in San Francisco and Provincetown, Massachusetts. His work has been exhibited throughout California, and in New York City, Provincetown, and Torino, Italy. Yamrus has been the recipient of various awards, including the California Discovery Award and a citation from *New Mexico Photographer* magazine. He is represented by the Wessel O'Connor Gallery, New York.

Index of Photography

Book casing: *Walt Whitman*, circa 1854. Daguerreotype, 3¾ × 2¾ inches. (Courtesy of Rare Books and Manuscripts Division, The New York Public Library, Astor, Lenox, and Tilden Foundations)

Frontispiece: John Dugdale, *Wedding Bouquet*, 1995. Cyanotype on watercolor paper, 10 × 8 inches.

FRANK YAMRUS

12 *Tommy-Pods*, 1994. Gelatin-silver print, 7 ¼ × 7 ¼ inches.
15 *Kurt-Infinity*, 1995. Gelatin-silver print, 7 ¼ × 7 ¼ inches.
 (Courtesy of the artist and Wessel O'Connor Gallery, New York)

ROBERT FLYNT

18 *Untitled*, 1994. Digital ink-jet print, 30 × 37 inches.
23 *Untitled*, 1993. Chromogenic print, 24 × 20 inches.
25 *Untitled*, 1995. Digital ink-jet print, 17 × 12 inches.
28 *Untitled*, 1993. Chromogenic print, 24 × 20 inches.
30 *Untitled*, 1995. Two-panel chromogenic print,
 24 × 30 inches.
 (Courtesy of the artist and Witkin Gallery, New York)

STEVE MORRISON

33 *Untitled*, from the series *Of the Terrible Doubt of Appearances*, 1991.
 Toned gelatin-silver print, two photographs, 4 ½ × 7 inches.
37 *Untitled*, from the series *Of the Terrible Doubt of Appearances*, 1991.
 Toned gelatin-silver print, two photographs, 4 ⅝ × 7 ¼ inches.
39 *Untitled*, from the series *Of the Terrible Doubt of Appearances*, 1990.
 Toned gelatin-silver print, 4 ½ × 3 ½ inches.
40 *Untitled*, from the series *Of the Terrible Doubt of Appearances*, 1990.
 Toned gelatin-silver print, 4 ¼ × 3 ¼ inches.
 (Courtesy of the artist and Wessel O'Connor Gallery, New York)

JOHN DUGDALE

42 *Summer Bath*, 1994. Cyanotype on watercolor paper, 10 × 8 inches.
45 *Self-Portrait in Rondout Creek*, 1994. Cyanotype on watercolor paper, 10 × 8 inches.
46 *Citrus Fruit on Parlour Table*, 1994. Cyanotype on watercolor paper, 10 × 8 inches.
48 *Comrades*, 1994. Cyanotype on watercolor paper, 10 × 8 inches.
51 *My Spirit Tried to Leave Me*, 1994. Cyanotype on watercolor paper, 10 × 8 inches.
55 *Self-Portrait with Ancestor*, 1994. Cyanotype on watercolor paper, 10 × 8 inches.
57 *Parlour Mantel with Flair Vases*, 1994. Cyanotype on watercolor paper, 10 × 8 inches.
 (Courtesy of the artist and Wessel O'Connor Gallery, New York)

BILL JACOBSON

58 *Songs of Sentient Beings #1530*, 1995. Gelatin-silver print, 24 × 20 inches.
61 *Songs of Sentient Beings #1114*, 1994. Gelatin-silver print, 20 × 24 inches.
64 *Interim Couple #1198*, 1994. Gelatin-silver print, 10 × 8 inches
67 *Interim Couple #1173*, 1994. Gelatin-silver print, 8 × 10 inches.
69 *Interim Couple #1164*, 1994. Gelatin-silver print, 8 × 10 inches.
70 *Interim Landscape #125-17*, 1989. Chromogenic print, 19 × 19 inches.
 (Courtesy of the artist and Julie Saul Gallery, New York)

RUSSELL MAYNOR

73 *Joel*, 1984. Polaroid print, reproduced 20 × 16 inches.
 (Courtesy of the artist)

MARK BEARD

75 *Untitled*, 1992. Hand-colored gelatin-silver print, 14 × 11 inches.
76 *Aidan at Chiswick House*, 1992. Hand-colored gelatin-silver print, 14 × 11 inches.
 (Courtesy of the artist)